joy lasts

SISTER WENDY BECKETT

joy lasts

ON THE SPIRITUAL IN ART

DISCARD

THE J. PAUL GETTY MUSEUM, LOS ANGELES

�⟩

Library of Congress Cataloging-in-Publication Data
Beckett, Wendy.
 Joy lasts : on the spiritual in art / Sister Wendy Beckett.
 p. cm.
 ISBN-13: 978-0-89236-843-3 (hardcover)
 ISBN-10: 0-89236-843-8 (hardcover)
 1. Spirituality in art. 2. Religion in art. I. Title.
 N8248.S77B33 2006
 701'.1--dc22
 2005026063

For my dear friends

NUALA AND IAIN

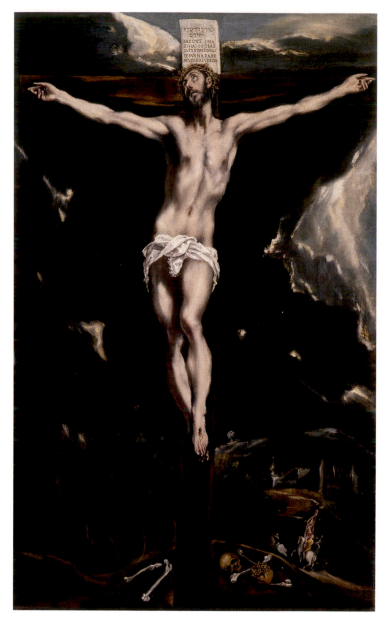

El Greco
CHRIST ON THE CROSS
ca. 1600–1610

Christ on the Cross by El Greco is an astonishment and a delight to me, far more so than much other religious art in the Western tradition. This may be a surprising view, and I can only reach a point where my gratitude to this painting sounds reasonable by starting a long way off. We have to weave our way, our happy way, of course (this being a book about art), through definitions and reproductions, while I strive to clarify why this one painting — now in the collection of the Getty Museum, like all the works I will discuss — seems to me such a miracle of grace.

The terms *religious* and *spiritual* are often used indistinguishably. But they have very different meanings. The confusion arises from the possibility that a work may be spiritual but not religious, or else religious

but not spiritual: the higher honor is always accorded to *spiritual*, and to it all works of art aspire. It is what we have in mind when we call a work of art great: it is what makes the encounter with such a work a life-enhancing moment. To be religious, though, a work of art must depict religious images. If the artist is not particularly gifted, he (or she) may paint a scene of very well-intentioned religious significance — a Crucifixion, say, or a Madonna — but what he shows us on the canvas sits there, dull and inert. If we find religious inspiration in it, it will come from our own faith, not the artist's vision. The work has merely acted as a springboard. We have used it but not entered into it, as we are drawn to do with a spiritual work of art.

For me, Cézanne is a great example of an artist whose work is not religious, but is spiritual. When people ask me which artist is my favorite, and I say Cézanne, they often go on to ask — my heart sinks — Why? My usual answer, not untrue, is that he is so

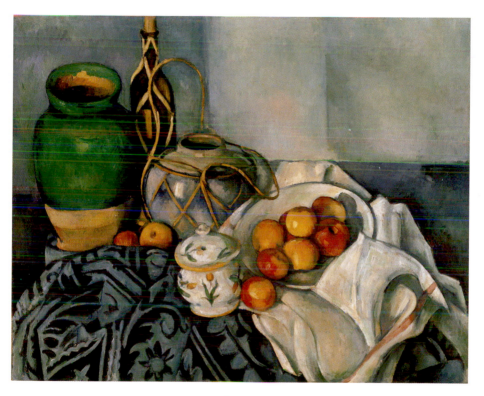

Paul Cézanne
STILL LIFE WITH APPLES
1893–94

ravishingly beautiful. The sheer color in his paint-
ings is almost unbearable in its richness; his modest
objects become wonderful images, weighty with con-
templation. But the beauty goes deeper than appear-
ance. We are hardly surprised that he took two years
in painting *Still Life with Apples.* He loved creating
these still-life tableaux, arranging every element,
making sure the fruit was of a long-lived variety, so
that he would at least get the essentials drawn

before, as was inevitable, the apples and pears began
to rot, and he loved taking out from the cupboard his
old friends, the blue ginger jar he used so often, the

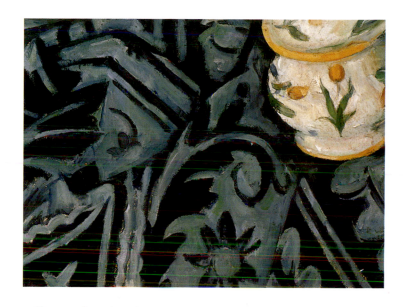

tall rum bottle, the swelling green and cream vase,
the napery. The dark blue cloth with its black
arabesques is as familiar as the ceramics, yet his
arrangement, his personal interior landscape, is
always thrillingly different. Glass, clay, cloth, the
wood of the table, the plaster of the wall, a spilt plate
of small apples: from these he has created a world of
contrasts and correspondences, where flat depends
for its form on billowing, where a complex of
heights clusters closely in a dense plane of space,
where there is a marvelous sense of a solidity that
seems implicitly to offer comfort.

In Cézanne's work, appearance is something wrested
with immense honesty and effort from the flux of
the temporal. What agonized Cézanne — and he
never felt he had solved the difficulty — is that the
world constantly changes. Light wanes and waxes;
shadows move; one step to right or left, and the
painter is looking at a scene not wholly the same.
This desire to be true both to what he saw and to the
circumstances in which the material world dictates
it must be seen; to celebrate both permanence and
transience; to honor both the uniqueness of the
artist's vision — Cézanne described it as his "petite
sensation"— and the universality of what is actually
seen, tormented him less when his theme was still
life. There he could achieve a relative stability that
nature, shifting and perishable, can never have.
There he could spend time without the fear of time's
destructiveness. In calling this picture spiritual,
then, I am not making the slightest religious claim
for it: no secret reference to Eve's apple in Paradise
here. There is no narrative, either, as there is in

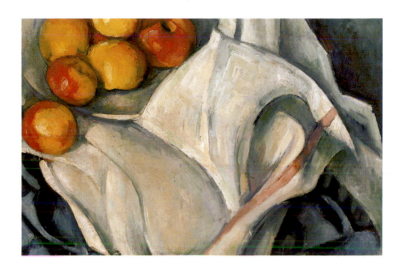

many seventeenth-century Dutch still lifes, where we have a palpable sense of the interrupted breakfast. This is pure image, moving us to our depths with its beauty and integrity, its passion for truth, its sense of wonder. The longer we look at *Still Life with Apples,* the more profoundly it will reveal to us our own potential for depth, perhaps our own need for integrity. There can be as much painful longing in our response as there is joy.

Conventionally, this spiritual, nonreligious masterwork should be compared with a picture that is religious but not spiritual. The perfect example is that

image of the Sacred Heart that in my childhood hung in many homes: of no aesthetic value at all — horrible in a way — but everything in it was alight with spiritual meaning. It took one straight into the presence of what it meant, the love of Jesus Christ, and so was a power for good. But all depended on one's own faith. The unbeliever stared, aghast! Like the image of the Sacred Heart, not all works of art are aesthetically powerful, and yet their purely religious content may be very high indeed. Perhaps I can get closest to what I mean by looking at a leaf in a late fourteenth-century missal from Bologna. It is, remember, a missal, a prayer book, created to help the owner respond adequately to the Mass. The leaf comes from the pages that give the text of the Mass said on the Feast of Saint Andrew. Andrew was Saint Peter's brother, like him a fisherman. Luke tells us in his Gospel that, on a day when Jesus was teaching on the shore of Lake Gennesaret, the people were crowding around him, and he asked a local fisherman, the future Saint Peter, if he could preach from

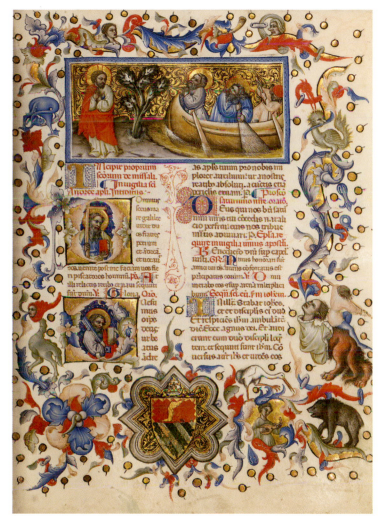

Master of the Brussels Initials
THE CALLING OF SAINTS PETER AND ANDREW
between 1389 and 1404

his boat. Afterward, Jesus told Peter and Andrew to let down their nets. All night they had fished and caught nothing, but this time the catch was enormous, overwhelming. Peter, ever emotional, fell to his knees and asked Jesus to go away ("Depart from me, for I am a sinful man, O Lord"). Jesus did go away, telling the men to follow him — which, as we know, they did, Peter to become head of the embryonic Church, the holder of the keys, and Andrew to die on the cross, himself a martyr. The story, as so delightfully shown in this leaf, might not have the meaning for the unbeliever that it has for me. I find it enchanting. The artist — we call him the Master of the Brussels Initials, because we do not know his actual name — makes no attempt to glamorize his figures. There is a stumpy Lord, looking back over his shoulder rather enigmatically at the disturbed brothers, and there is Peter in an agony of response, deeply moved by Jesus, deeply afraid of this strange new vocation. And behind him, as he seems always to have been, is the hulking form of his supportive

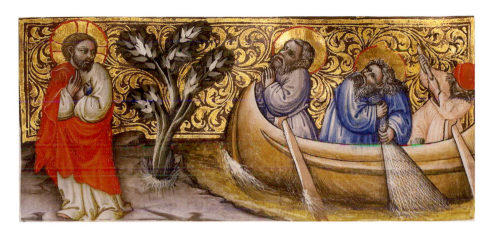

brother, busily gathering up his miraculous catch of fish. He is as perturbed as Peter as to what it all means. The tilt of that wondering head, bushy with hair and beard, shows his silent perplexity. The small tree between them and Jesus seems to be pushing itself up into the air. This is truly a different world, where blossoms can appear in an instant and hoary-handed fishermen become apostles. Below, to remind the reader what happened next, the artist includes two small inserts, one of Saint Andrew with his

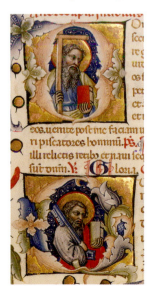

cross, one of Saint Peter with his keys, both with the gold backgrounds that tell us these are realities of heaven and not of earth.

It is religion that makes this illustration effective: religion is the sole motive for its existence. But the religious element in a work may not always be so dominant. Here is another picture of Saint Andrew, this time by that very great artist Masaccio. Although he was to die in his twenties, it was his understanding of Giotto, of bodily solidity, of emotional intensity, of the way human beings actually exist in space, that kick-started the Renaissance in fifteenth-century Tuscany. If we knew nothing about Saint Andrew, what would we make of this picture, from a religious standpoint? We would know it showed a saint, because of the halo, and a martyr, because of the cross. Otherwise, Masaccio gives us the portrait of a weary man of middle age, unassailable in his dignity, learned (he holds a massive book), formidable only in his girth — the one attribute both representations

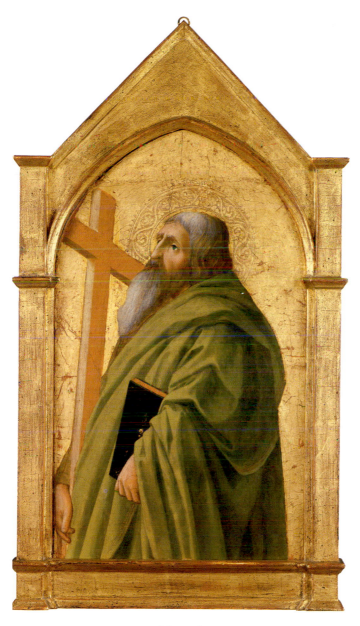

Masaccio
SAINT ANDREW
1426

of the saint have in common! But how discouraged is the droop of Andrew's hands, how exhausted his upward gaze. There is little here for religious encouragement. Yet the painting is taken from one of the side panels of a huge, fifteen-foot altarpiece, centered on the Madonna and Child. It is a work of extraordinary force, but I am not affected emotionally. Despite the grandeur of Masaccio's depiction of the human form, it does not draw me nearer to the grandeur of this particular saint. Here, religious iconography is being used for decorative, not strictly religious, ends and can only illustrate a meaning.

The question of the effectiveness of religious iconography is a fascinating one. Visions, it might be assumed, occupy a place at the heart of it. But while depictions of visions may be religious in their iconography, they may not be in their impact. This leaf from a Bolognese antiphonal illustrates the vision of Isaiah, when he beholds the Lord. Isaiah in ecstasy is at the bottom, while we see, glorious

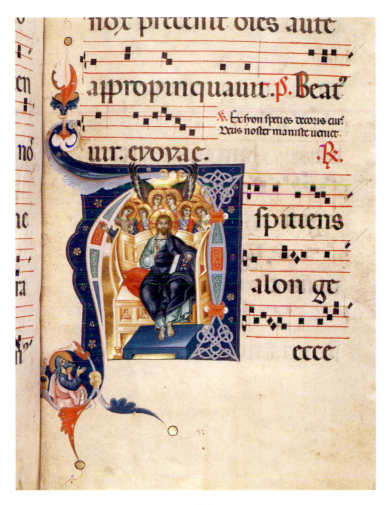

Master of Gerona
INITIAL A: CHRIST IN MAJESTY
late 1200s

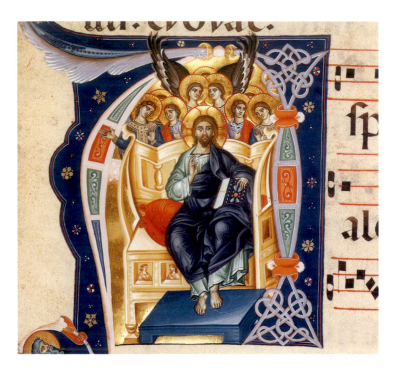

above, his vision. What is immediately striking is the witty and delighted use the artist, the Master of Gerona, has made of the initial *A* that encloses the divine throne. The letter springs majestically from its interlace, swelling out into decorative reds and greens; it then contracts briefly back into its interlace, before swooping and soaring into an ever-rising elaboration of wing and shell and leaf, swirling upward as if reluctant to stop. One final puffball seems a finale, to which the irrepressible

master cannot resist adding an insouciant and delicate arabesque. This is glory indeed, the *A* of the prophet's *Aspiciens* (written *Aspitiens* here) changed into patterns of splendor into which God and his angels fit felicitously. God's throne curves and dips, his garments glitter, the angels are patterned in an almost symmetrical chorus. The emphasis is on the elaboration, not on God: we feel an amused amazement, but not awe. Yet this again is a book to be used on the altar, for the choir to sing from, as sacred in

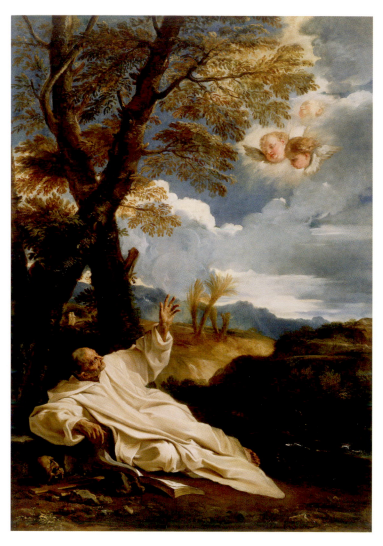

Pier Francesco Mola
THE VISION OF SAINT BRUNO
ca. 1660

its setting as the Masaccio altarpiece. Wonderful art though this may be, it wears its iconography lightly, its visual potential abounding but its spiritual depths not plumbed.

Two splendid paintings depict precisely this deeply spiritual theme of visions. A vision or ecstasy dares to reveal a soul in most intimate union with God: there could hardly be a more serious, more affecting image for anyone who also yearns to live in that sacred union. In *The Vision of Saint Bruno* Mola depicted the founder of the Carthusians, an order of men who essentially live in solitude, meeting only in church. The saint's habit — white, ample — extends over the ground, as if to symbolize for us the surrender of his heart. He glimmers in the dusk, an aging hermit lost in prayer. His face is half averted, but that tremendous lifted arm tells us that he sees. What he sees Mola does not venture to depict. The one element I find off-putting is the cherubs' heads bobbing like balloons above him,

but they are perhaps more apt for their very ineptitude: it is impossible to depict in physical terms what has overthrown Bruno and irradiated his prone body. The very trees seem to bow to an unseen presence. And yet, while I see all the ingredients of ecstasy here, I miss the thing itself. What excites me most is that expanse of gleaming cloth, with its secrets and spaces. It speaks to me more powerfully than Bruno does.

Murillo's *Vision of Saint Francis of Paola* is a very different — and, for me, more successful — presentation of religious ecstasy. Murillo, of course, is a hit-and-miss artist. His misses, when he lapses into sentimentality — all those adorable little Baby Jesus and little Saint John pictures, both infants spotlessly clean and burnished — are never more than charming. They are always this, at least, because Murillo is such a great technician: no artist has excelled him in the tactility of his textures. But when he succeeds, he strikes straight to the heart, and this work seems to

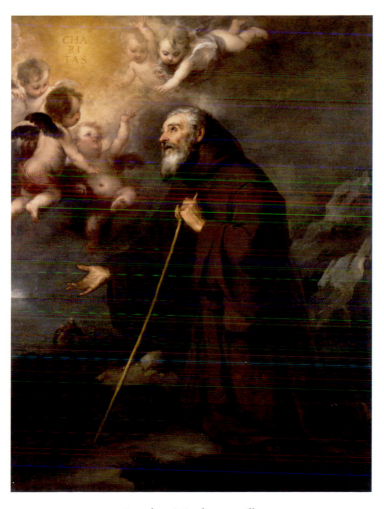

Bartolomé Esteban Murillo
THE VISION OF SAINT FRANCIS OF PAOLA
ca. 1670

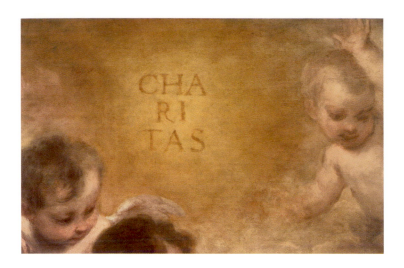

me one of his great hits. He has almost wantonly
foregone his chief strength, his ability to make us
feel substances: in the supernal glow seeming to
emanate from the word *Charitas*, it is not easy to
respond to the great swathes of coarse brown in
which the saint is clad, and we can barely make out,
in the distance, an enactment of one of the saint's
miracles. All our attention is drawn with inescapable
power to that pleading face, the profundity of the
offering that Francis makes of himself to God.
The five small angels (dear little creatures, like all
Murillo's children) are insignificant. Francis does
not see them; he is looking in adoration at his Lord.

I find that I cannot regard this picture without tears. I do not actually cry, but my eyes sting. And this brings me a great step nearer to what I want to say about El Greco's *Christ on the Cross*.

I have always had a difficulty in talking about religious art. Partly this is because I am a nun, and I need to be careful that nobody feels I want to proselytize. This would distract from what I do want to do,

which is to be a conduit for a meeting between the art and readers. So I generally confine myself to writing about secular art, where there is spiritual depth enough without raising other difficulties. But this is

only part of my problem, and a small part. My real problem is one of which I am not proud, and it comes down to cowardice. Not like Saint Francis or Saint Bruno, alas, but, as best I can, I too love Our Lord, and I find images that make very real his suffering almost unbearable. In a somewhat similar fashion, I can imagine anyone whose father or grandfather died of exhaustion — peasants crushed beneath the burden of a hopeless life of toil — might shrink from discussing Millet's *Man with a Hoe*, for example.

This painting frightened fashionable Paris in the well-fed nineteenth century, and so it should. Millet was accused of being a radical, while he intended only to arouse the national conscience to the plight of the laboring poor. It is a heartrending work — the ground so barren, the tool so flimsy, the man so wretched and despondent. If our own family had known these sadnesses at first hand, the picture would doubtless be even more upsetting. La Tour's

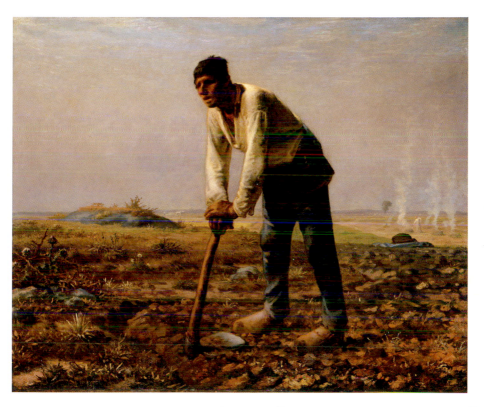

Jean-François Millet
MAN WITH A HOE
1860 – 62

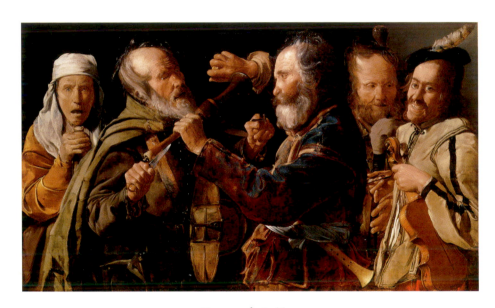

Georges de La Tour
THE MUSICIANS' BRAWL
ca. 1625–30

Musicians' Brawl is of the same kind. It is perhaps even more upsetting in that the two beggars on the right enjoy this foolish unpleasantness. These are beggars, social outcasts; one even appears to be blind. Yet they wrangle. It is a disheartening window on the human potential for violence and meanness of spirit.

I can look at these works reluctantly, trying to protect myself behind admiration for the two artists' techniques, their passionate involvement with their themes. After all, both are protesting, Millet more obviously, and with that protest I align myself. But there is nowhere to hide when the theme is the suffering of Jesus, a suffering brought about, as we know, by his desire to redeem the world from the miseries of its sinfulness. Every Christian is involved personally in the Passion, and to achieve enough emotional distance to speak about such art with intelligence and insight is a painful challenge to me.

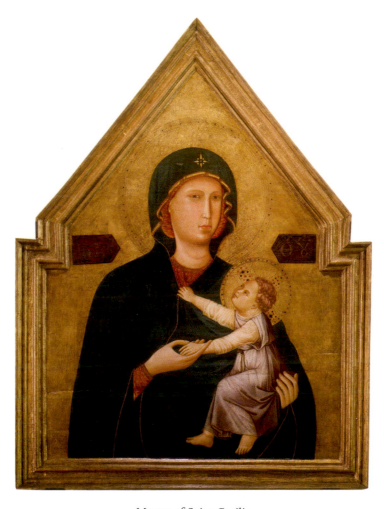

Master of Saint Cecilia
MADONNA AND CHILD
ca. 1290–95

Naturally, not all religious art deals with tragedy. By far the most frequent images are of mother and child. They differ, as we might expect, in their religious forcefulness. The Master of Saint Cecilia, at the end of the thirteenth century, was still influenced by Byzantine art, where the icons — sacred images that are as much visual prayer as artistic statement — dominate. I have only recently come to appreciate icons, with their strange and haunting power, and I warm very much to this Madonna, with her thin, intelligent face and dreamy expression. The small Jesus may not be wholly successful in realistic terms, but the child has great appeal. Yet I wonder whether it is enough to be appealing, whether this depiction gives a sense of the radical difference between this young mother and child and any other. The sheer stiffness of the Byzantine style, however unrealistic, does convey a sense of the sacred, emphasizing that these figures are not only of earth. Renaissance art, far more effective realistically, far more beguiling and convincing, can all too often give us the image

of a lovely young woman with a beautiful baby, and only the addition of the halo tells us this is the Mother of God and her Son. Yet delightfully as the image is humanized in this work, that aura of the spiritual escapes me.

Fra Bartolommeo was an artist who was also a priest, and he painted from the heart. His greatest work, *The Rest on the Flight into Egypt with Saint John the Baptist*, is a grand and beautiful invention. Christian imagination has loved to embroider on the small details of the life of Christ, in which the Gospels took very little interest. Matthew's Gospel tells us that Joseph was warned in a dream to take Mary and the child to Egypt, because Herod was seeking to kill him. Herod does kill all the baby boys he can find, but the Holy Family stays safely in Egypt until Herod dies and it is safe to return. Those few lines have been expanded by legendmakers into various adventures. Fra Bartolommeo, as befits his noncredulous and sophisticated temperament, deals very lightly

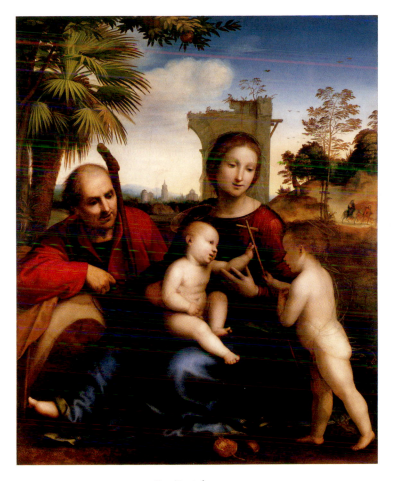

Fra Bartolommeo
THE REST ON THE FLIGHT INTO EGYPT WITH
SAINT JOHN THE BAPTIST
ca. 1509

with the story. Saint John has been conjured up from nowhere to hand his small second cousin (his mother, Elizabeth, being cousin to Mary) a cross made from reeds. Mary is unprepared and holds back her child's arm, but Jesus knows even then that

the Cross is his destiny. The details of the scene are resolutely symbolic. There is a pomegranate, which medieval imagination had decided was a symbol of the Passion: that deep red color, and all those generative seeds, once the rind is pierced. There are palms, to foreshadow the palms strewn before Jesus on Palm Sunday, when he entered Jerusalem to die.

There is a ruined arch, weirdly marooned in the desert, to make it clear that the rigidities of the Roman Empire have crumbled and we are in the Kingdom of God. Fra Bartolommeo adds the pathos of a noble and gentle Saint Joseph, outside the circle of intimates but staying contentedly on watch. There is only a faint pretence of realism, yet it suffices. We may not believe in the Flight into Egypt as such, but we do believe that Mary is a woman of the utmost graciousness and beauty, and that from the beginning her son, both human and divine — impossible to imagine — accepted the full sorrow of our misguided world. The child does not want to die; he takes the reed cross sadly, but take it he does. The great work is immensely powerful on every level. It is what religious art is always aspiring to be, that is, a depiction of religious truth with profound spiritual impact. It is a triumph of religious sensibility.

Yet despite the greatness of Fra Bartolommeo's picture, I am ashamed to admit that I would rather, for

my own pleasure, look at Poussin's *The Holy Family*,
where there is no sadness and John and Jesus merely
embrace. One can read premonitions into the pic-
ture, Poussin being the most subtle of artists, an
intellectual who planned every element for its signi-
ficance to the whole, and a poet who intuitively knew
how to make a theorem sing. Mary and Elizabeth
exchange looks that are serious, almost foreboding.
Soldiers in the far distance point out a boat, a deli-
cate allusion to the Flight into Egypt. Even the
flowers which the putti strew are, after all, cut
flowers, and the lovely pink of the garment crumpled
on the grass, or the white cloth on the putto's rosy
arm, could, if we are so minded, suggest to us that
final stripping on the cross, when the nakedness that
is so appealing in the infant Jesus changes into a
humiliating degradation. But I am not so minded. I
console myself that I love this Madonna because it is
by Poussin, that beloved master of luminous clarity,
but really I acknowledge that the great attraction is
the lighthearted joy. Here are the innocents who are

Nicolas Poussin
THE HOLY FAMILY
ca. 1651

not on the edge of martyrdom but who live in a secure world, and adults who, if only faintly, smile. Objectively, there may not be much to choose from between this painting and Fra Bartolommeo's. Both are paintings of spiritual power. Yet, subjectively, I know that what tilts the balance for me is the serenity of Poussin's tone.

You will notice that I still hang back from the Passion, although we are now within sight of our El Grecoan goal. Let me continue to lead up to it.

What do I make of Correggio's *Head of Christ?* Is not this what I claim to need, an image of the Passion that is not too distressing? Most images of the veil of Veronica, which is essentially what Correggio has painted, are indeed distressing. The legend had it that a holy woman, Veronica, whose name translates as "true image," ran up to Jesus as he carried his cross and wiped his bleeding face with her veil. She found on it a perfect replica of his appearance. This legend was immensely popular, especially in times when

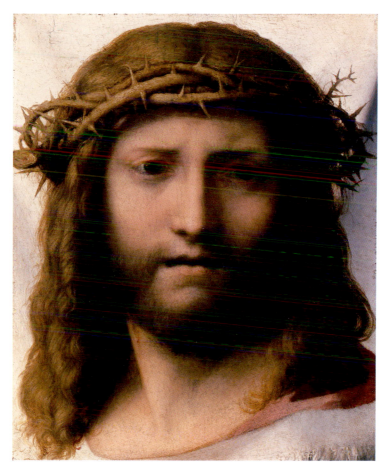

Correggio
HEAD OF CHRIST
ca. 1525–30

devotion to Christ was concentrated on his suffering. But the image of necessity is that of a man almost in extremis, dragging himself to his death. Correggio, invariably sweet, a born crowd-pleaser, gives us a lovely head, crowned with thorns but still regal, still warm and consoling, a Jesus whose pain is so heroically contained that it disappears. Yet this bothers me; it seems to disrespect the reality of that pain. Jesus did suffer, and I am not happy with pretense. If I have to face his Passion, then I want the truth of it, not a cosmetic version, no matter how beautiful. I feel the same about Domenichino's *The Way to Calvary*. All the props are there, as it were: cross, whips, brutal soldiery, Jesus fallen. But although his face is pallid, it is the face of one wholly in command. This is not the Jesus who cried out in agony in the garden and called out on the cross: "My God, my God, why have you forsaken me?" This is a man playing the part of Jesus. Domenichino's reverence impeded him from getting beyond the beautiful and tackling the appalling truth of his subject.

Domenichino
THE WAY TO CALVARY
ca. 1610

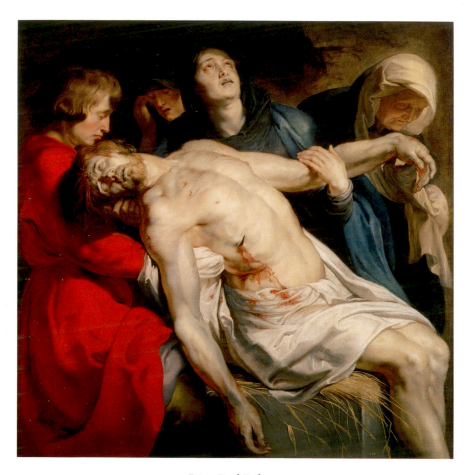

Peter Paul Rubens
THE ENTOMBMENT
ca. 1612

Rubens is a different case. *The Entombment* is the epitome of the Passion picture that turns me away, speechless, more shame to me. Rubens was a dedicated Christian, at Mass every morning, on his knees every evening. He excelled in all he did, whether as artist, scholar, diplomat, husband, friend, or connoisseur, yet he always retained his humble heart. He was a man without malice. What makes all his images of the Passion so affecting is that Rubens painted them for himself, whatever the commission. He felt he needed to meditate on what his Lord had suffered for the sins of mankind; for Rubens himself. So he enters imaginatively into that suffering, reliving it as he traces with his brush the blood-stained heaviness of that dead body, an anguished body, and the reactions of the two people — Mary and John — who loved Jesus in a way that Rubens knew he himself could never love anyone. All in this tremendous painting rings so wretchedly true, from the grieving women at the back to the prickly straw in the foreground. The blood has dried on Jesus. He

is so brutally, pitiably dead that even the garment of the living — John's scarlet tunic — is more alive. Yet it is that abandoned body that completely fills the mind as we gaze, so completely that I find it impossible to continue with the rationality of words.

For one who writes about art, this is a grievous defeat. Rubens painted *The Entombment* to stir up devotion, to encourage contrite love. Can I not associate myself with so fine an endeavor?

Since it is sadly obvious that I cannot, you can at last appreciate, you readers who have patiently borne with me, why the El Greco painting comes to me with such a power of relief. For here is a Crucifixion, *Christ on the Cross*, that I can look at and enter into, and yet one that does not dodge the issue, as I rather unkindly accused Correggio of doing, and Domenichino, too. El Greco was an economical artist. Once he had found an image that worked for him, he used it repeatedly, with minor adaptations.

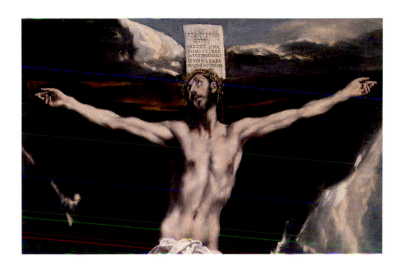

That *Christ on the Cross* is not unique in his oeuvre
is something not to deplore but rather to celebrate.
Because here — and this for me is unique — I find
the Passion understood rather than shown. El Greco
was no mystic. He was a stern and fussily litigious
man, yet when he painted he moved effortlessly into
a world akin to that of his contemporary, Saint John
of the Cross, mystical poet. In his art, if not in his
life, El Greco understood what Jesus meant when he
uttered that final cry: *Consummatum est*: it is done,
it is accomplished. It was a transforming moment
in my life when I, who had always found Holy Week
and Good Friday almost unendurable, suddenly saw

that, in fact, Jesus died in an ecstasy of joy. He had been sent by the Father to bring life into the world. He had done it, achieved what the Father intended. His agony, physically and emotionally, may not have been any the less, but in his will Jesus knew the great liberation of having reached an almost impossible goal. All this I see, mystically, in El Greco. The intensity of the surrounding, enveloping darkness — the moral darkness of a race that could torture anyone to death, innocent or not — is just beginning to be pierced by the radiance that Jesus has brought us. That sharp and by no means comforting light shines on the scattered bones of other men that lie scorned beneath the cross. It spotlights the wealth and power of established authority as its representatives depart, the knights on horseback with flowing banner, and emphasizes the solitude of the Lord. El Greco does not alleviate his sacrifice with grieving family and friends. No, Jesus dies, as we all die, alone with his God. He dies as we hope to die, looking upward, his determination set upon his father's will and its

consummation. But the most marvelous touch, to me, is the depiction of the dying Jesus as already triumphant over death: he does not escape death; he passes through it and out of it. His body spirals upward like a white flame, radiating out as he spreads his arms to share the light with the defeated shadows. We are shown, in the distance, the steeples and walls of a defended city. Jesus brings before us the uselessness of defense, the joy of abandonment to a divine purpose. Saint Paul once wrote that when we are weak, we are strong, a mystical paradox that this painting makes visual. It is Jesus in death and in resurrection, dying in pain and rising in glory, utterly true to the dual dimensions that make him the spiritual center of so many lives. Joy lasts and grief passes: that is what I see in *Christ on the Cross.*

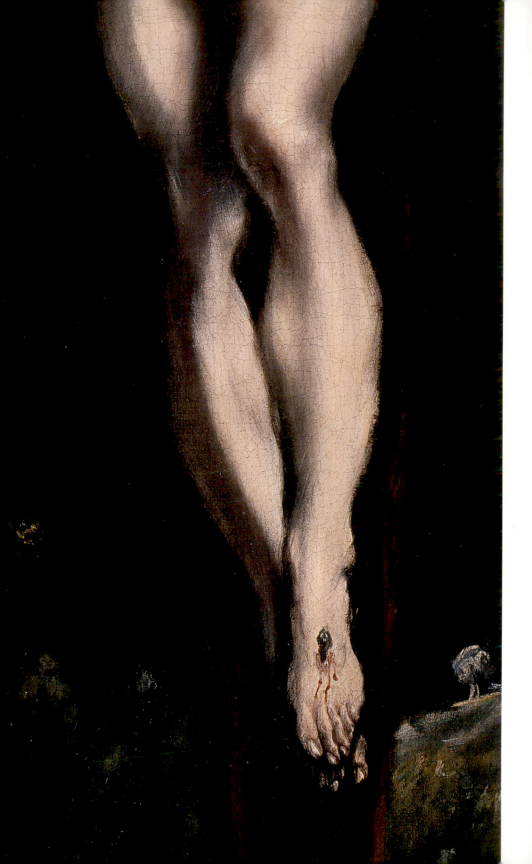

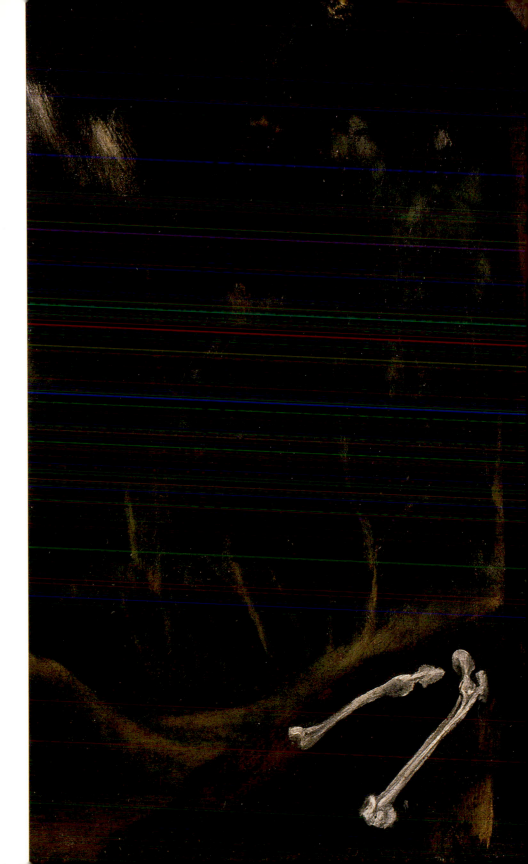

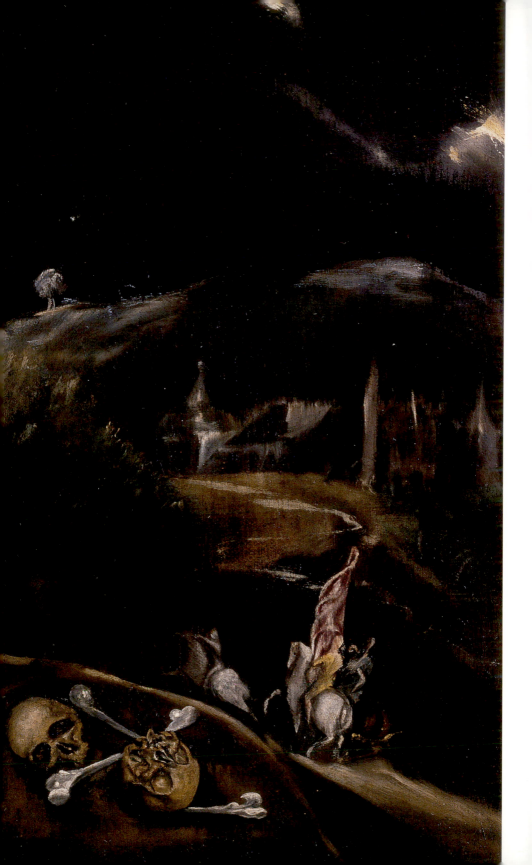

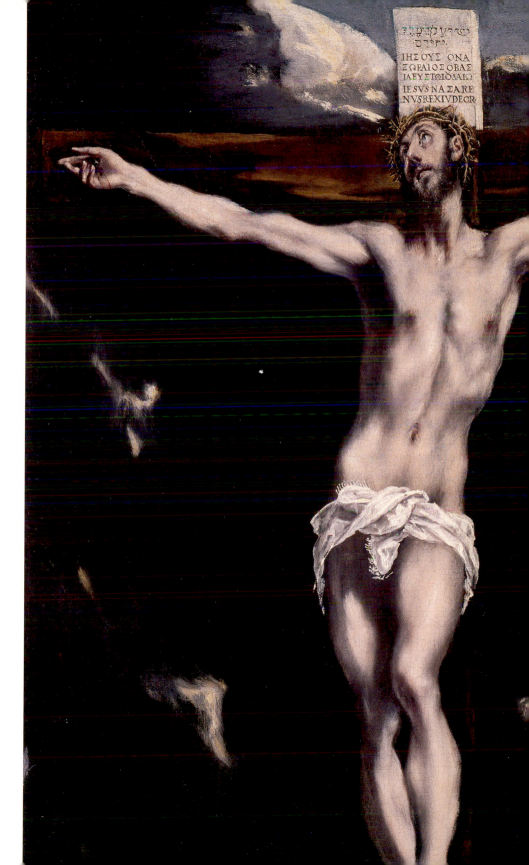

Turning from religion — and I am afraid that I may have taken you farther down this path than you expected or desired — and turning to the appreciation of art — that much smaller and yet still important subject — what is the moral of all this? I think it is the need to be true to what you are when you look at art. It is you who look, no one else. What your neighbor thinks is of interest, and it may be that it is what you yourself would like to think, too. There is, after all, a comfort in aligning one's reactions with those of scholars and experts. All too many of us are excessively humble in front of art, fearing to make fools of ourselves if we are unable to see the virtue of one piece or the faults of another. But of what use is art appreciation if it does not give voice to our own personal reaction? Of course, we must pause if we

find ourselves isolated in an opinion. We must study to find out why we differ from those who—we shall meekly feel—know better. But if time, reading, and, above all, looking long and well at a work leave us discontented with it, then there is nothing for it but to come clean with the truth. In this case, my pain over a work like that of Rubens is a tribute to his genius. Only because he felt himself so harrowed by the Passion and could so masterfully express his sorrow in fleshly imagery, am I so affected. But I am increasingly grateful to El Greco for showing me that my temperamental limitation is not completely disabling, and that, if we wait, each of us will find a way to experience that challenge that great art alone can offer. It is the waiting, the seeking, the refusal to pretend, that matter.

LIST OF ILLUSTRATIONS

All works of art are from the collection of the J. Paul Getty Museum, Los Angeles.

El Greco (Greek, 1541–1614), *Christ on the Cross*, ca. 1600 – 1610. Oil on canvas, 82.6 × 51.6 cm (32½ × 20⁵⁄₁₆ in.). 2000.40.

Paul Cézanne (French, 1839 –1906), *Still Life with Apples*, 1893–94. Oil on canvas, 65.4 × 81.6 cm (25¾ × 32⅛ in.). 96.PA.8.

Master of the Brussels Initials, *The Calling of Saints Peter and Andrew*, from a missal; Bologna, between 1389 and 1404. Tempera colors, gold leaf, gold paint, and ink on parchment bound between wood boards covered with blind-stamped sheepskin; leaf: 33 × 24 cm (13 × 9⁷⁄₁₆ in.). Ms. 34, fol. 172a.

Masaccio (Italian, Florentine, 1401–1428), *Saint Andrew*, 1426. Tempera on panel, 44.9 × 30.2 cm (17¹¹⁄₁₆ × 11⅞ in.). 79.PB.61.

Master of Gerona, *Initial A: Christ in Majesty*, from an antiphonal; Bologna, late 1200s. Tempera colors, gold leaf, and ink on parchment bound between original wood boards covered with black-stained sheepskin, rebacked; leaf: 58.3 × 40.2 cm (22 15/16 × 15 13/16 in.). Ms. Ludwig VI 6, fol. 2.

Pier Francesco Mola (Italian, 1612 – 1666), *The Vision of Saint Bruno*, ca. 1660. Oil on canvas, 194 × 136.8 cm (76 3/8 × 53 7/8 in.). 89.PA.4.

Bartolomé Esteban Murillo (Spanish, 1617 – 1682), *The Vision of Saint Francis of Paola*, ca. 1670. Oil on canvas, 188 × 146 cm (74 × 57 1/2 in.). 2003.144.

Jean-François Millet (French, 1814 – 1875), *Man with a Hoe*, 1860 – 62. Oil on canvas, 80 × 99.1 cm (31 1/2 × 39 in.). 85.PA.114.

Georges de La Tour (French, 1593 – 1652), *The Musicians' Brawl*, ca. 1625 – 30. Oil on canvas, 85.7 × 141 cm (33 3/4 × 55 1/2 in.). 72.PA.28.

Master of Saint Cecilia (Italian, active 1290 – 1320), *Madonna and Child*, ca. 1290 – 95. Tempera and gold leaf on panel, 87 × 66 cm (34 1/4 × 26 in.). 2000.35.

Fra Bartolommeo (Italian, 1472 – 1517), *The Rest on the Flight into Egypt with Saint John the Baptist*, ca. 1509. Oil on panel, 129.5 × 106.6 cm (51 × 41 15/16 in.). 96.PB.15.

Nicolas Poussin (French, 1594 – 1665), *The Holy Family*, ca. 1651. Oil on canvas, 100.6 × 132.4 cm (39 5/8 × 52 1/8 in.). 81.PA.43 (Owned jointly with the Norton Simon Art Foundation, Pasadena).

Correggio (Italian, 1489/94 – 1534), *Head of Christ*, ca. 1525–30. Oil on panel, 28.6 × 23 cm (11 1/4 × 9 1/16 in.). 94.PB.74.

Domenichino (Italian, 1581 – 1641), *The Way to Calvary*, ca. 1610. Oil on copper, 53.7 × 67.6 cm (21 1/8 × 26 5/8 in.). 83.PC.373.

Peter Paul Rubens (Flemish, 1577 – 1640), *The Entombment*, ca. 1612. Oil on canvas, 131.1 × 130.2 cm (51 5/8 × 51 1/4 in.). 93.PA.9.

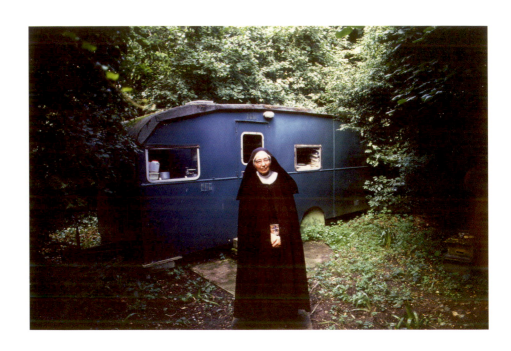

PROJECT STAFF

Mark Greenberg, *Editor in Chief*

John Harris, *Editor*
Catherine Lorenz, *Designer*
Stacy Miyagawa, *Production Coordinator*
Louis Meluso and Jack Ross, *Photographers*